LORETTA LUX

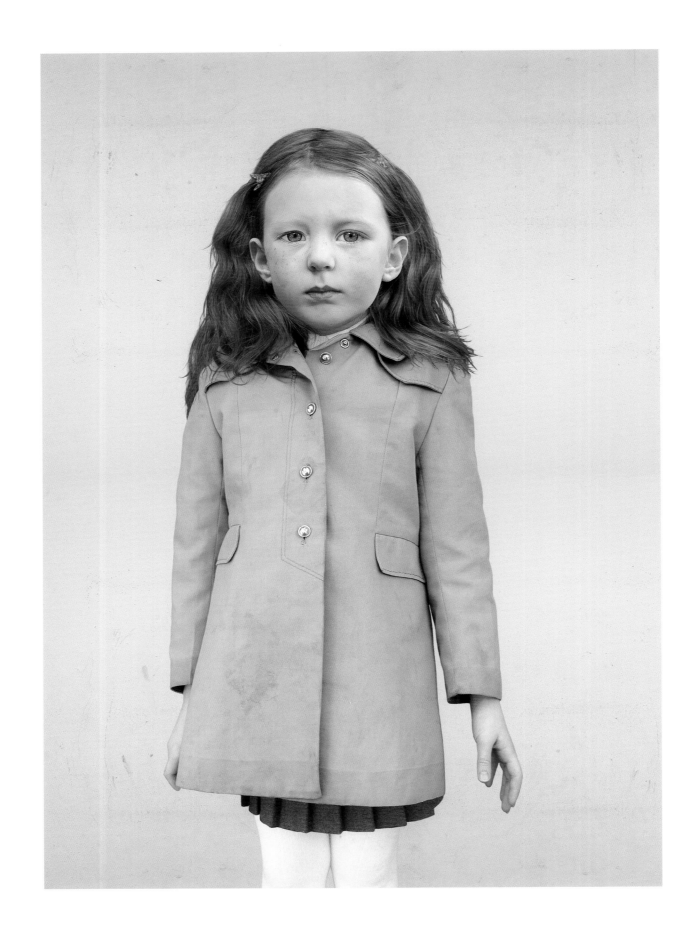

LORETTA LUX

Essay by Francine Prose

aperture

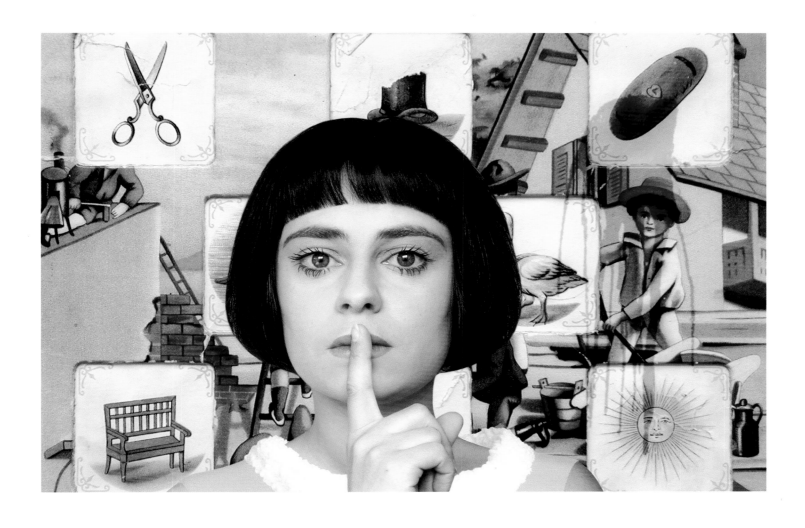

The Hush, 1999

IMAGINARY PORTRAITS

Francine Prose

In a Loretta Lux photograph, a beautiful, well-dressed child inhabits a storybook space located somewhere between a Tiepolo firmament and a commercial-portrait backdrop—a landscape sweetened by the pastel tints of a Victorian nursery and suffused with an icy, postnuclear light. The children look a little like dolls, a bit like fashion models, something like the fantasy creatures of some shutterbug Henry Darger, and ultimately reminiscent of some particular child recalled from a Lewis Carroll photograph, an Old Master portrait, or a medieval painting.

These children have no interest in us, no wish to engage or charm us. They occupy that insular dream state that we recognize as childhood, or in any case as a certain idea of what it means to be a child. They are innocents streaming clouds of glory, and yet at the same time they spark that uneasy frisson of the pink-cheeked infant entertainer. For we can no longer see children as the Victorians did, viewing their outer beauty as a sign of spotless inner lives. These days, children who are too pretty raise uncomfortable questions about the ways certain adults project their erotic longings on children. And yet, for all their evocative beauty, there is nothing about these children to suggest that they are anything but unearthly, and untarnished. And so we can only look within ourselves for the reasons we find Loretta Lux's photographs so unsettling.

Like every child, the children in these pictures have secrets from the adult world, secrets more urgent and real to them than the reality around them. Even when they stare out of the frame, they do not seem to see us. But mostly their gaze is turned inward, at once clear and glassy-eyed, transparent and opaque. Their eyes are startlingly bright and clear, expressionless and empty, the eyes of Siberian huskies or of alien children in science fiction.

Heirs of the aristocratic tots who sat for the Spanish masters, descendants of the preadolescents who modeled for Bronzino and Pinturicchio, these children wear costumes that have been chosen with considerable thought and care, costumes that are intended to be admired. The unreality and the spareness of the backgrounds force us to register each detail of couture and coiffeur. We can hardly not notice that the little girl in *The Rose Garden* is dressed in almost precisely the same pink and green as the vegetation

around her; fresh sprigs bloom among the verdant rickrack of her rose-colored blouse. The blue diagonals on the dress in *Paulin* echo the gently peaking waves of the sea behind the model, just as the eponymous *Blue Dress* picks up the unlikely azure of the housing blocks in the background. Clothed in an emerald coat with white stitching, the tow-headed toddler in *Spring* seems about to levitate from the emerald meadow. Evoking a Balthus painting, as well as pilgrims on pious walking tours, *The Wanderer* pauses for a rest. Wearing an outfit Lolita might have worn on her first day in a new school, she rests her head against a knapsack so stylish that we almost wonder if it is a product she is selling. And yet, unlike fashion photographs in which the child model is the accessory, these pictures direct attention to the child rather than to what the child happens to be wearing.

In some cases, the children look as uncomfortable in their clothes as the little Spanish aristocrats pictured by Velázquez must have felt in those gowns as heavy and unyielding as armor. What must it have cost the boy in *Troll 1* and *3* to put that decidedly uncool ruff around his neck? We can fully understand why he looks so melancholy. And what patience it must have required from the girl in *Hidden Rooms 1* and *2* to sit still while her hair was twisted into those knobs at the sides of her head; the same forbearance, we imagine, that Velázquez's infanta must have shown as her tresses were being coiled into that dense nest of corkscrews.

Looking at Loretta Lux's photographs, we admire, as we are meant to, the beauties of the surface, the extravagant gorgeousness of the crafted object, here made to seem all the more wondrous because the compositions and the subjects are, in theory, so simple. Digitally altered Ilfochrome prints, these pictures testify to the marvels that can be worked with a good eye and a computer. Their size (they range from just under twelve to almost twenty inches on a side) is as intimate, as unintimidating, and as compelling of close inspection as a portrait by Hans Memling. Lux poses her models, the children of friends, most often against a bare wall and then digitally adds the backgrounds, borrowed from photographs she has taken in her travels.

The surfaces of these photos have a lustrous, pearlescent sheen that evokes the same magic the Old Masters knew how to produce with their long-lost alchemy of finishes and glazes. The light in *At the Window*, for example, evokes the golden glow of a Caspar David Friedrich or a Vermeer. The children and the artist

conspire to keep us riveted to the surface; their secrets are protected by a sort of sleight of hand that dazzles and diverts us. No wonder the children don't look at us, no wonder the space is so strange. No wonder nothing encourages us to imagine that we are seeing the "real" or "natural" child.

And yet the more their surfaces engage us, the more these images make us realize that, as soon as an artist such as Loretta Lux takes childhood as her subject, it becomes nearly impossible for us, or for her, to remain on the surface. A work of art that focuses on a child seems to burrow under our skin, tunneling back through time and memory to a world whose details we long to recall, yet cannot, and so we invent a myth that only inserts another layer between us and what we are trying to recapture.

Every child knows there are people who see children merely as larval adults and have no more interest in them than the non-entomologist has in the pupa in its cocoon. But there are other grown-ups, and I count myself among them, who must resist the urge to stare at every child who walks into the room. The mystery of childhood is as obsessively fascinating as the mystery of time. Perhaps that's because it *is* the mystery of time, of how hard and how quickly time works, and how much it can accomplish (aided by DNA). Unlike the more slowly evolving adult, the child makes us aware of how much is changing, second by second. In the child, we contemplate time's mystery with a certain narcissism, seeking tantalizing hints of who we were in the distant past and who we will be in the future. We want to ask children what used to be asked of the oracles. And the children in Loretta Lux's work are the sphinxes we imagine.

However much we might like to, we cannot stare at real children. Partly because our culture has identified staring at a child as a possible symptom of perversion. But also because, having been children ourselves, we know they are sentient beings who will notice us staring and, sensibly, wonder why. One advantage of having a child of your own is that you can look as long as you like. But beyond that, and to expand our view, art once more comes to the rescue. To look at the children in Chardin, in Velázquez and Goya, in Bronzino and Botticelli, at every angel and cherub, is to look at a child through a telescope and a microscope lent us by a genius. Though they have been dead for centuries, their subjects seem fully alive, wholly present. And, unlike real children, they will not mind how long we look. We can spend all day

contemplating an irreducibly individual, simultaneously transparent and opaque young person of a certain background, age, and class. We form a sense of this person that cannot be reduced to words or described as fully or eloquently as the artist has done with the image.

Such paintings, the products of long and repeated sittings, imply a transaction between the artist and the subject more sustained and focused than what generally transpires between a photographer and a model. And yet, strangely, photos of children often make us uneasy in ways that paintings (with perhaps the exception of Balthus) don't. The transfixed mutual adoration of many of Lewis Carroll's portraits is so intense that we can hardly bear to take in what they tell us about the charged relationship between the artist and his model. The work of Diane Arbus or Sally Mann makes us feel, in different ways, that we are being shown something no one else would or could show us, something we might not be meant to see. And Loretta Lux's work challenges us to solve the puzzle of why we are unnerved by an image that is so apparently innocent, and so beautiful. This is not a question that can be answered; part of what is artful about these photos is the sly intelligence with which they raise unanswerable questions and refer us back to the emotional rather than the cerebral.

Perhaps it's the nature of photography itself, or perhaps a residue of the way photography stops time, but formal photos of children—especially pale ones, as many of these are—often make us eerily aware of nineteenth- and early-twentieth-century memorial photography of the newly departed. They also have the uncanny effect of bringing to mind the dolls their child subjects might have dropped when called to quit their games and stop being children long enough to pose for their portraits. If the children in these photos blinked, we feel we might hear their lids snap shut. Tapping directly into that uncanniness, Loretta Lux's photographs inevitably bring to mind disturbing thoughts about childhood.

Though the children pictured here are real, they are acting in a drama in which they are not required to reveal one true thing about themselves, one single aspect of their own individual personalities. These children are engaged in make-believe, which most children happen to like. And that makes these pictures the very opposite of exploitative. Indeed, these images don't claim to tell us much about what it means to be a child.

They don't purport to give us a picture of how it feels to be very young, an image of childhood seen from the inside—the sort of thing we get from, say, a Helen Levitt photo of children behaving exactly as they would without the photographer present. Loretta Lux's photos are not about children acting like children, but rather about grown-ups looking at children, seeing in their former selves their own fairy tale of childhood.

Yet Lux's models are real kids. However much the computer has helped, these are photographs, not paintings. And yet (perhaps in part because Loretta Lux trained as a painter) they are like paintings, not only because of their seductive surfaces but also because of the way they demand prolonged looking. Like paintings, they reward sustained attention with deeper pleasure, with more information—and in this case, with secret messages from the recognizable world of actual children. The surfaces may be studies in unblemished perfection, but if we look a little harder we begin to note the Band-Aid, the anklet mark of the sock elastic, the bruised knee, the bright dot of the scratched mosquito bite. And what's that just behind the *Study of a Boy 1* and 2? A castle penciled on the wall? The blister, the scab, and the drawing are all intrusions of reality that the artist could have erased from her work but didn't—kept in perhaps as signifiers from the life outside the photos, the life in which these cherubs fell down and skinned their knees and naughtily drew on surfaces they weren't supposed to touch.

If the subject of childhood plumbs the depths of our psyche, it also resonates with the particular frequencies of history and culture. In addition to the scab or the bruise, the physical signs of what it means to spend your free time running and playing, these photos also resonate with signals from the history of childhood and from the childhood of the artist. The broken glass on the floor behind the barefoot girl in *Hidden Rooms 1* and 2 gives that room a history, as does the castle on the wall behind the boy in *Study of a Boy 1* and 2. These subjects are not nowhere. They are somewhere. And someone has been there before them; the room or the landscape is not the blank slate it might at first have seemed.

If every artist aspires toward the universal and the eternal, every artist also comes from a specific time and place. Once you know that Loretta Lux was born in 1969 and grew up in Dresden, in the German Democratic Republic, something about these children attaches itself to an era and a location.

As a child, the artist was taken to see the Old Master paintings in the museums of her native city, and she recalls reproductions of paintings of children by Velázquez and Rubens hanging in her childhood room. We cannot completely forget this, nor that German culture has produced some of the most beautiful and darkest writing about childhood—Grimm's fairy tales and Goethe's "The Elf King." And we can't help thinking of the ways in which, during Lux's childhood, the state channeled reality through the upbeat fantasy of Socialist realism. This was a society in which the cult of secrecy and surveillance was a daily reality. And we're tempted to conclude that it could hardly be mere coincidence that, in Loretta Lux's self-portrait (*The Hush*), the artist represents herself with her finger to her lips. The savvy East German child would most likely have learned, early on, the wisdom of keeping her mouth shut—a lesson that would only have intensified the natural secrecy of childhood.

Once you begin to look, hints of Eastern Europe keep surfacing. Though the monotonous faux-jaunty apartment blocks in the background of *The Blue Dress* could by now exist in nearly every country, it's the sort of architecture that we tend to associate with the soullessness of Eastern bloc housing. Something in a vest, in the cut of a coat—the stains on the jacket in *Marianne*—suddenly challenges our assumptions about when and where these styles come from. Are they dresses for Hummel figurines or for Eastern German children of the seventies, or are they the work of some trendy designer semi-ironically quoting the vintage past? And what do we make of the *Boy in a Blue Raincoat* in his slightly too large trench coat, that odd little schoolboy outfitted for some shadowy nursery school espionage?

Standing in front of these photographs, we may find ourselves moving from foot to foot, shifting position, much as we do in front of old paintings and daguerreotypes, as if each shift will tell us more about the surface and what is beneath. And what, really, is beneath? An image that cannot be reduced to words, but one that communicates something about childhood, about the world that children live in, about the way adults see them, about fashion, about technology, about art. Like children and like art, these photographs are mirrors in which we see ourselves, perhaps the selves we used to be merged with the faces of these small, mysterious strangers.

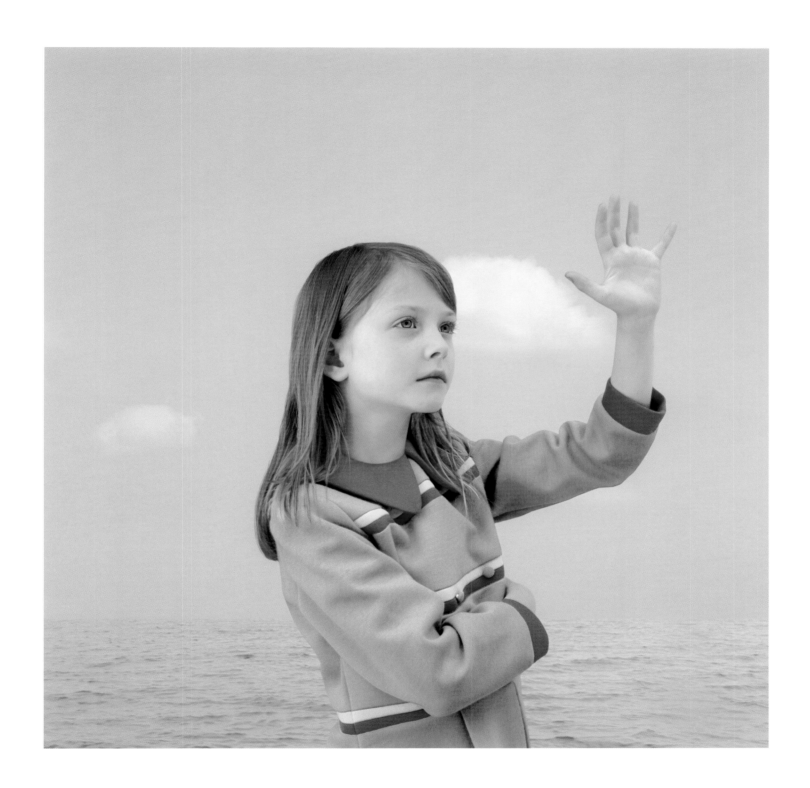

Lois 1, 2000

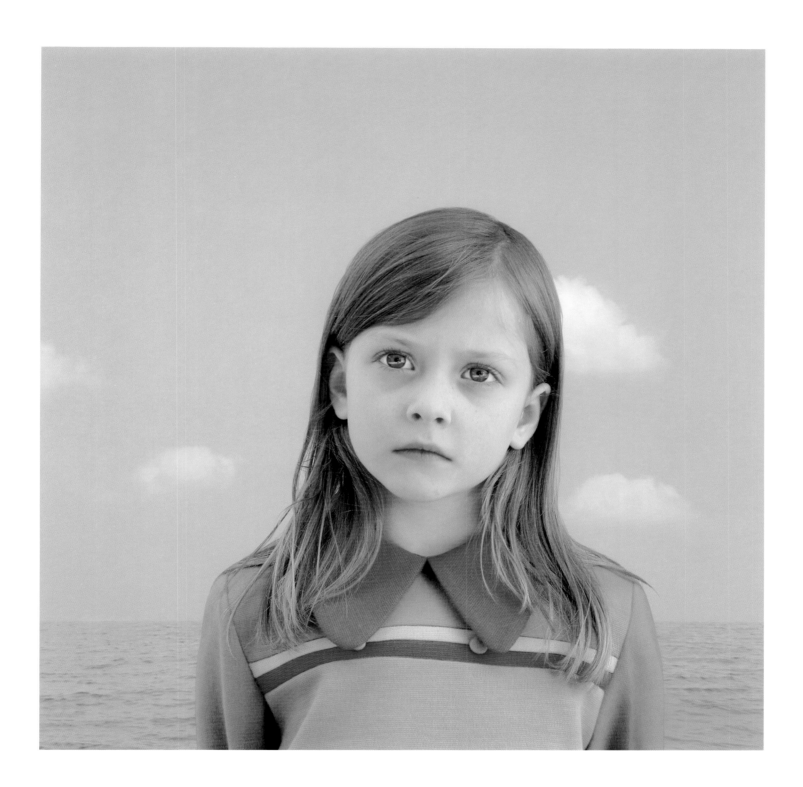

Lois 2, 2000

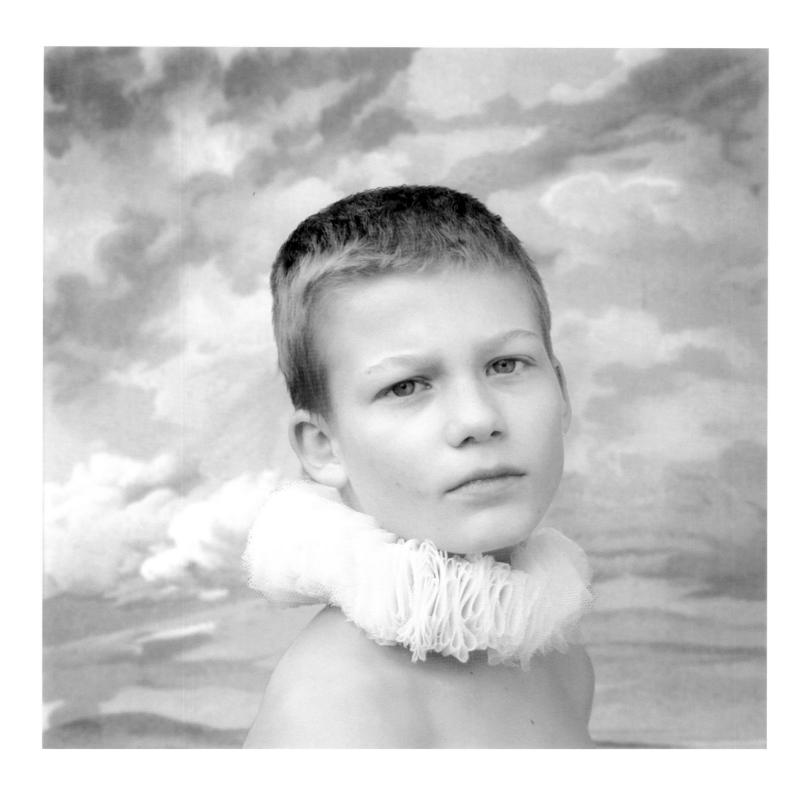

Troll 1, 2000

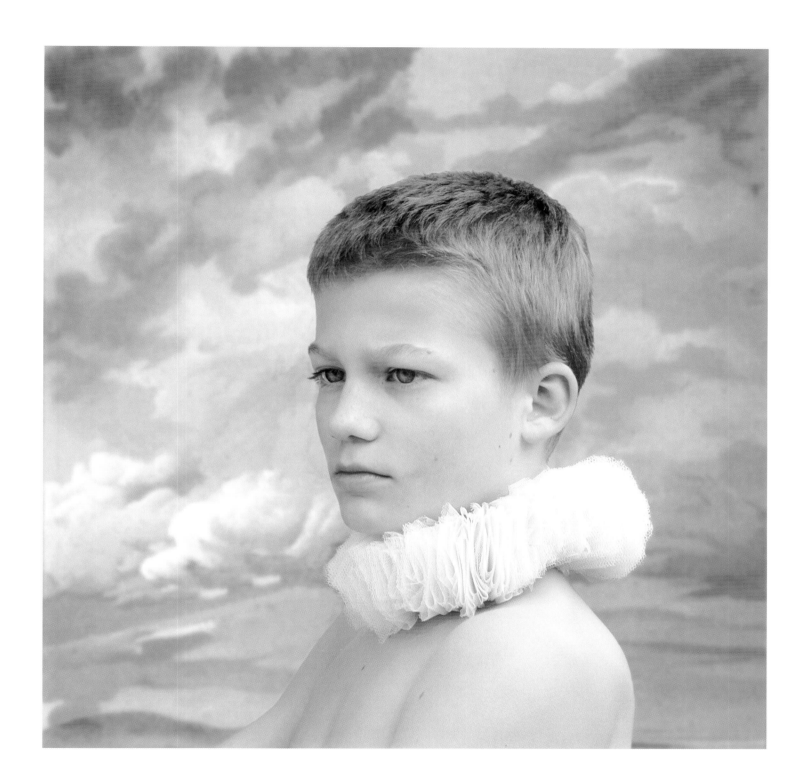

The Troll 3, 2000

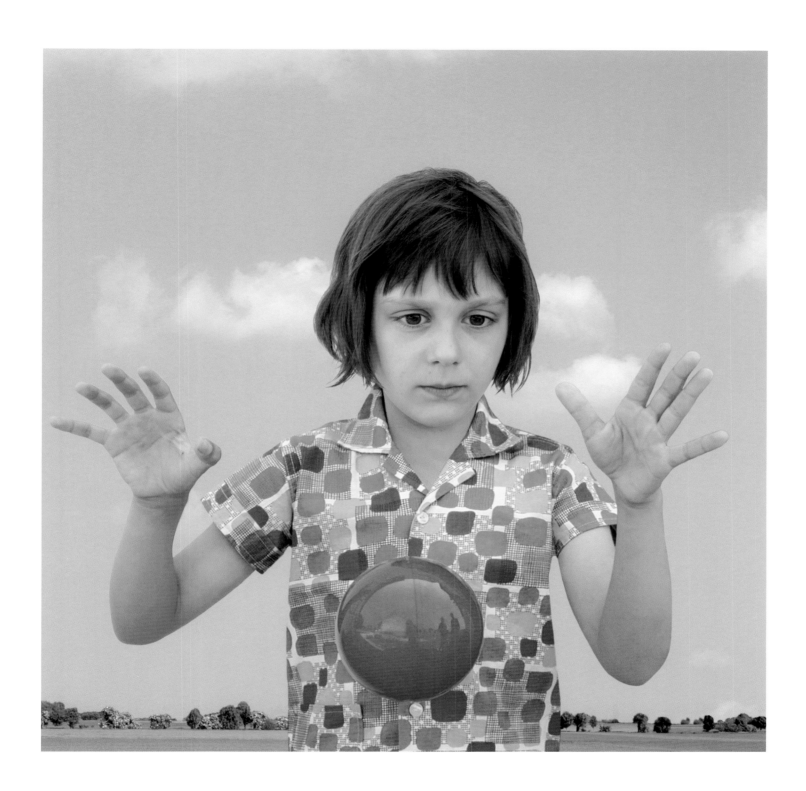

The Red Ball 1, 2000

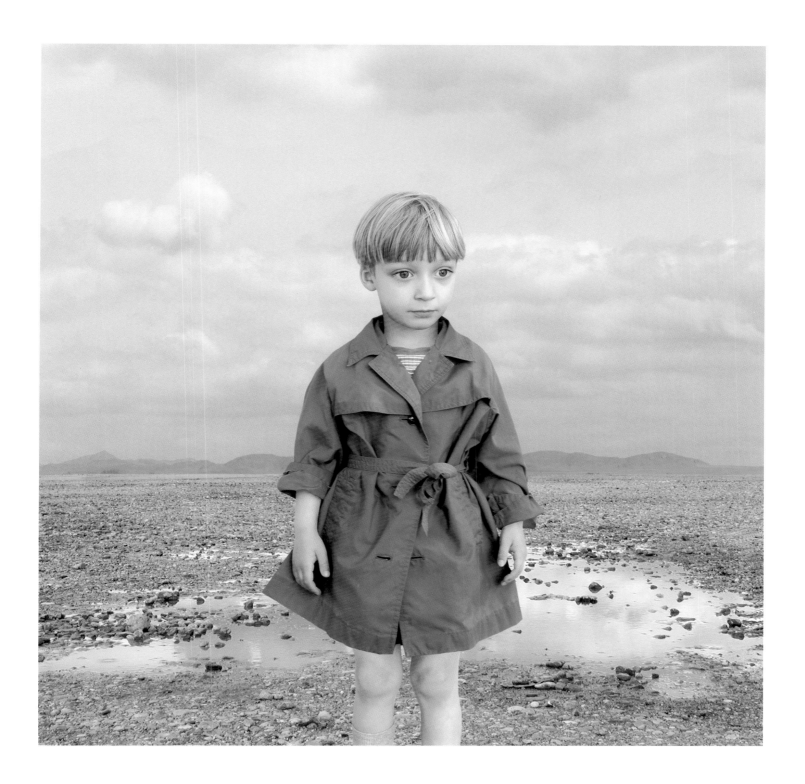

Boy in a Blue Raincoat 1, 2001

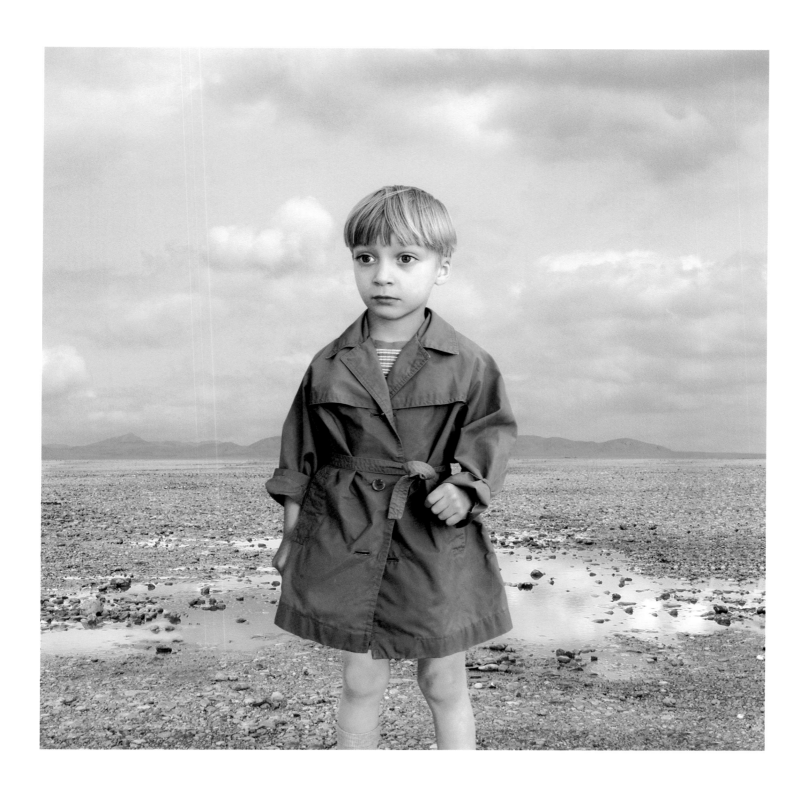

Boy in a Blue Raincoat 2, 2001

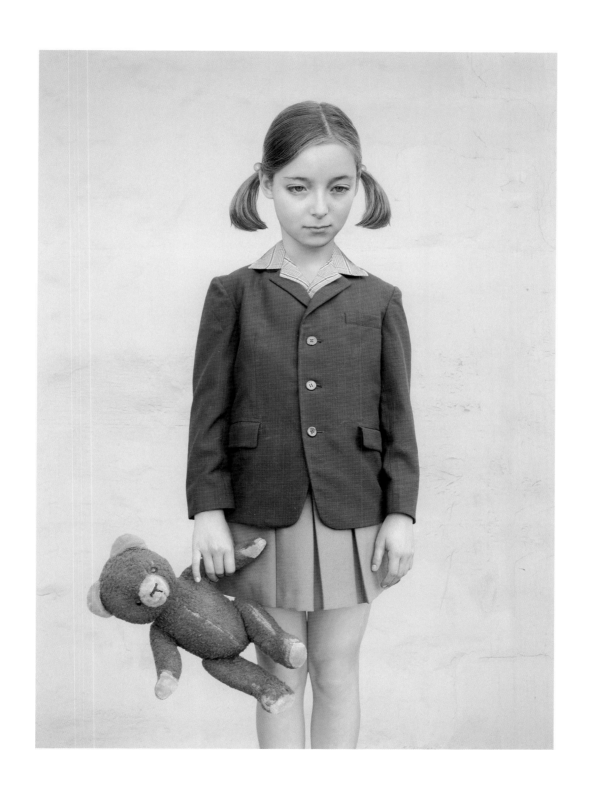

Girl with a Teddy Bear, 2001

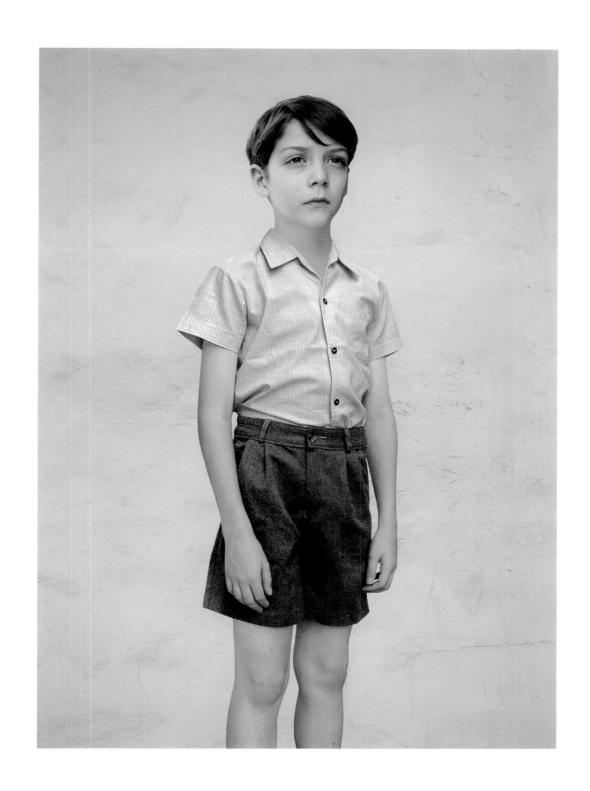

The Boy, 2001

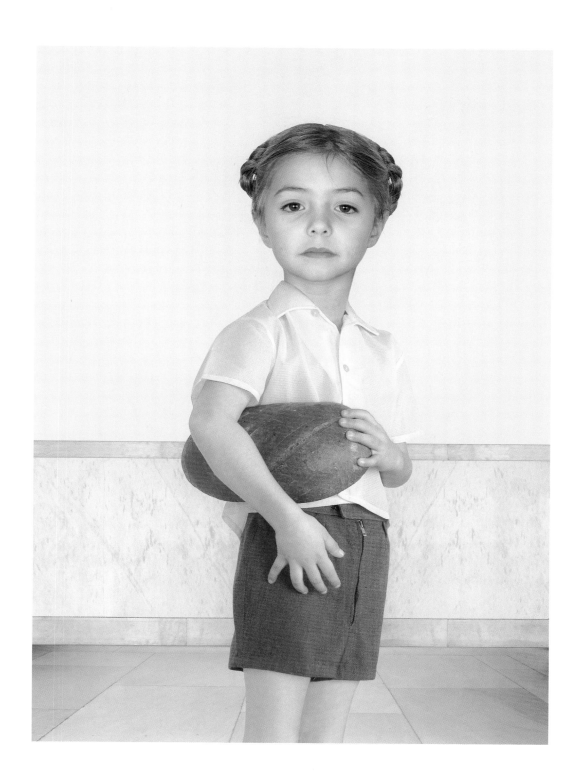

Girl with a Loaf of Bread, 2001

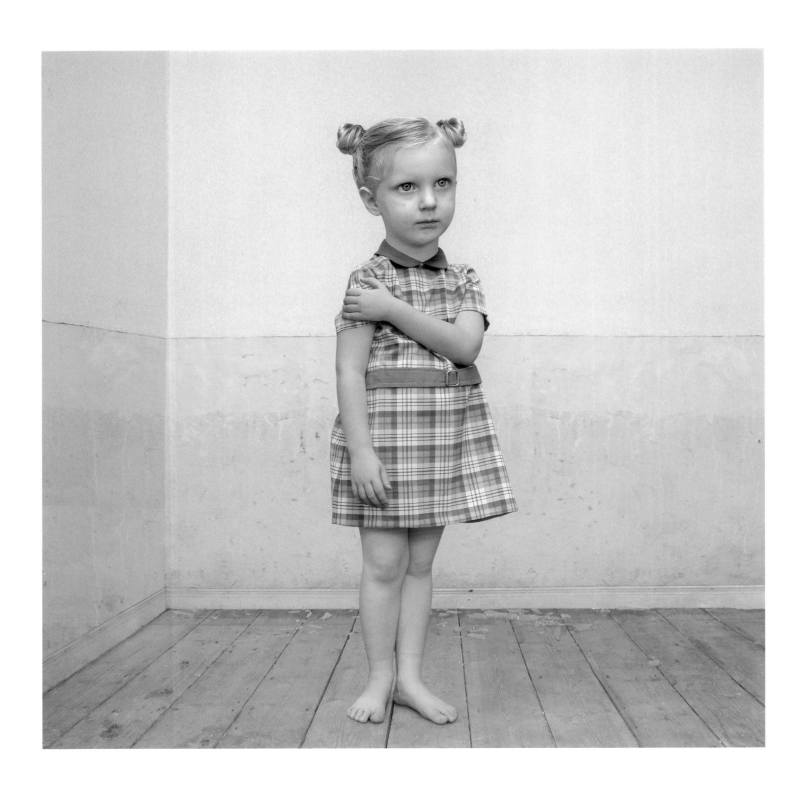

Hidden Rooms 2, 2001

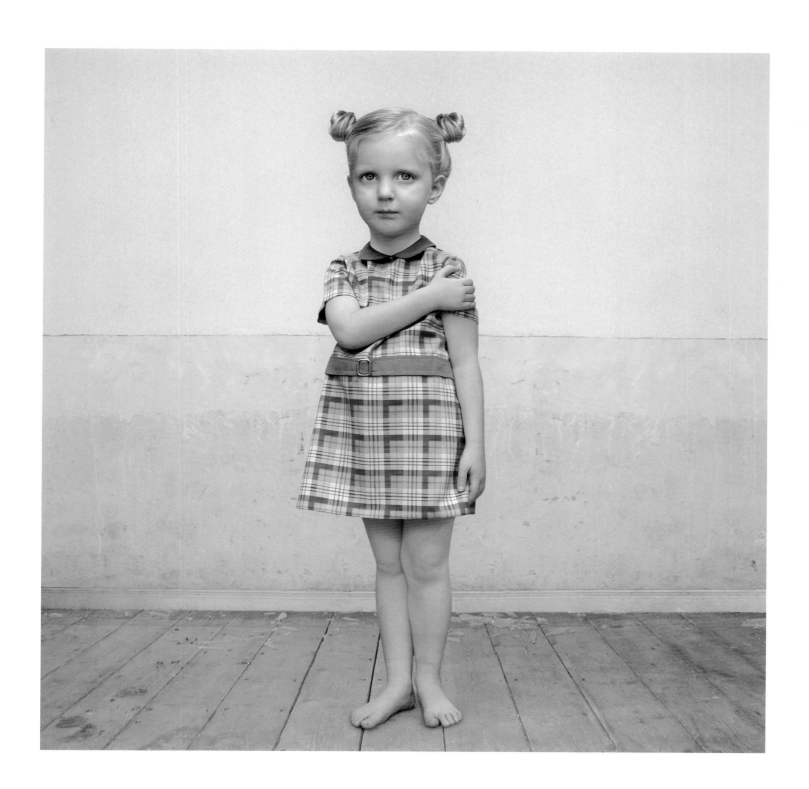

Hidden Rooms 1, 2001

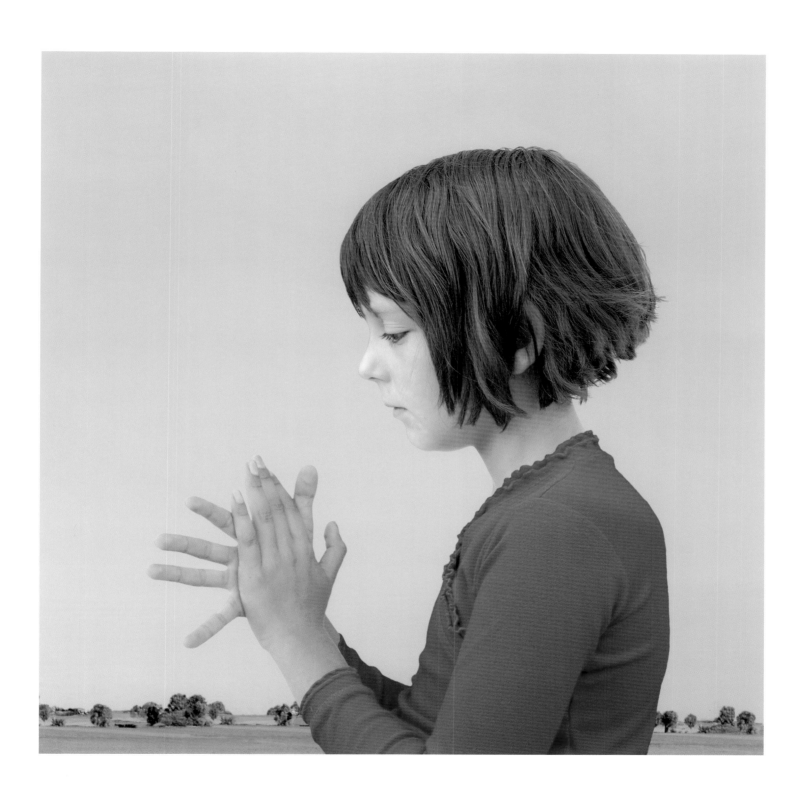

Three Wishes, 2001

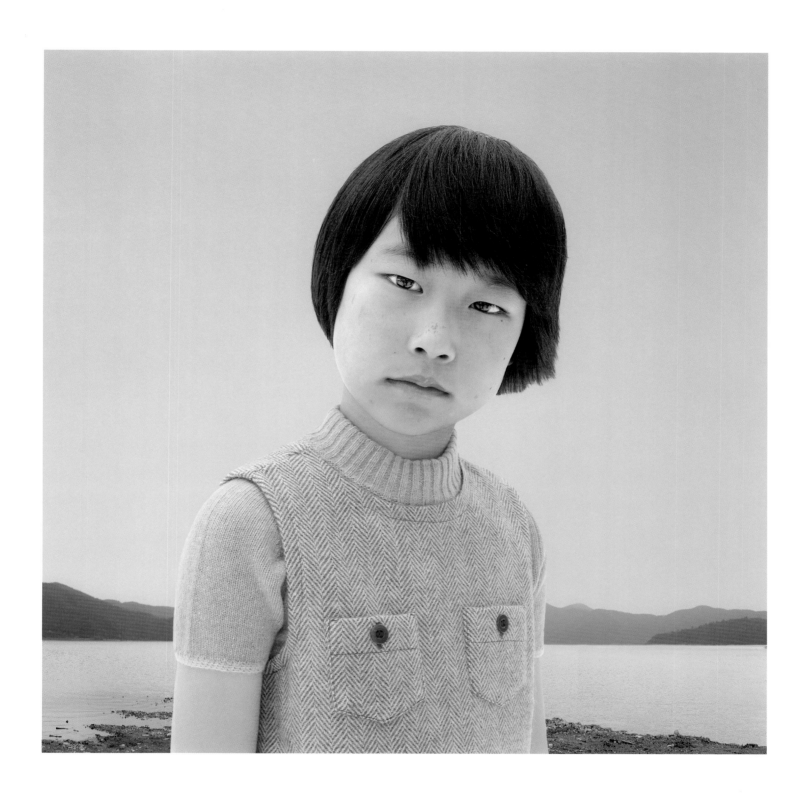

Megumi, 2001

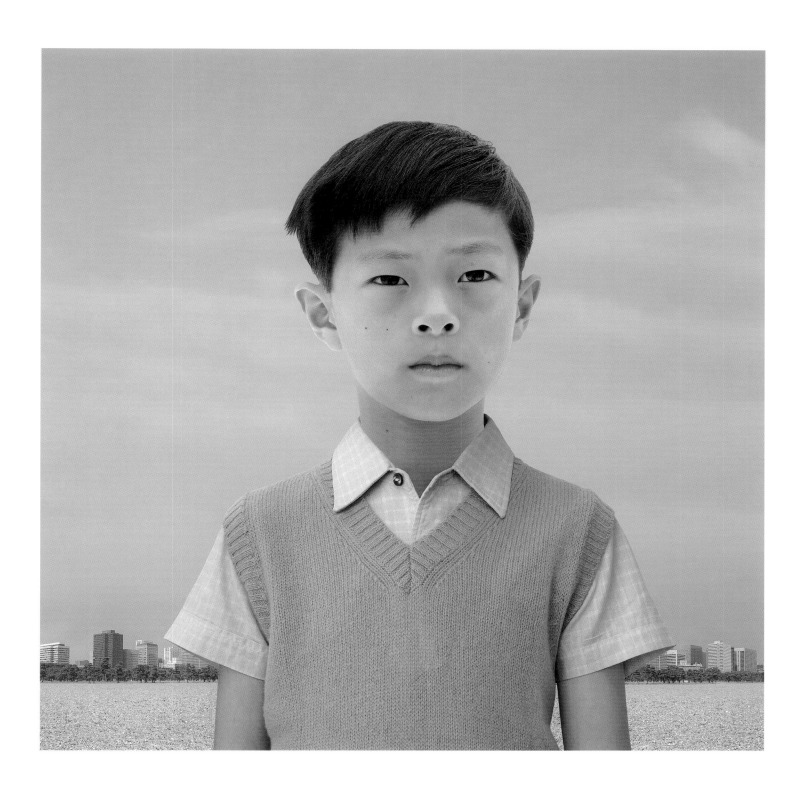

Keisuke, 2001

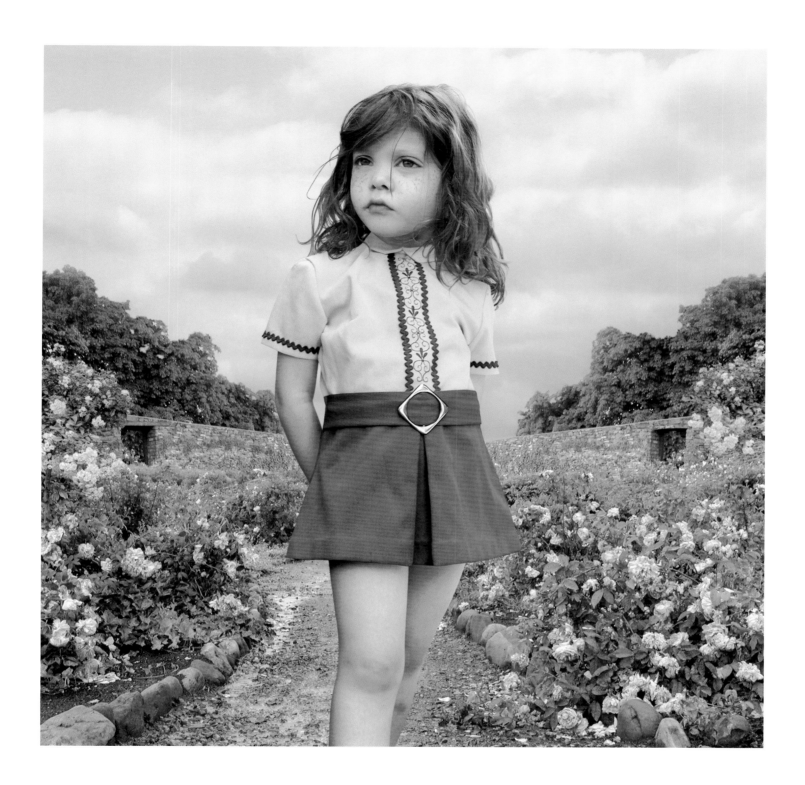

The Rose Garden, 2001

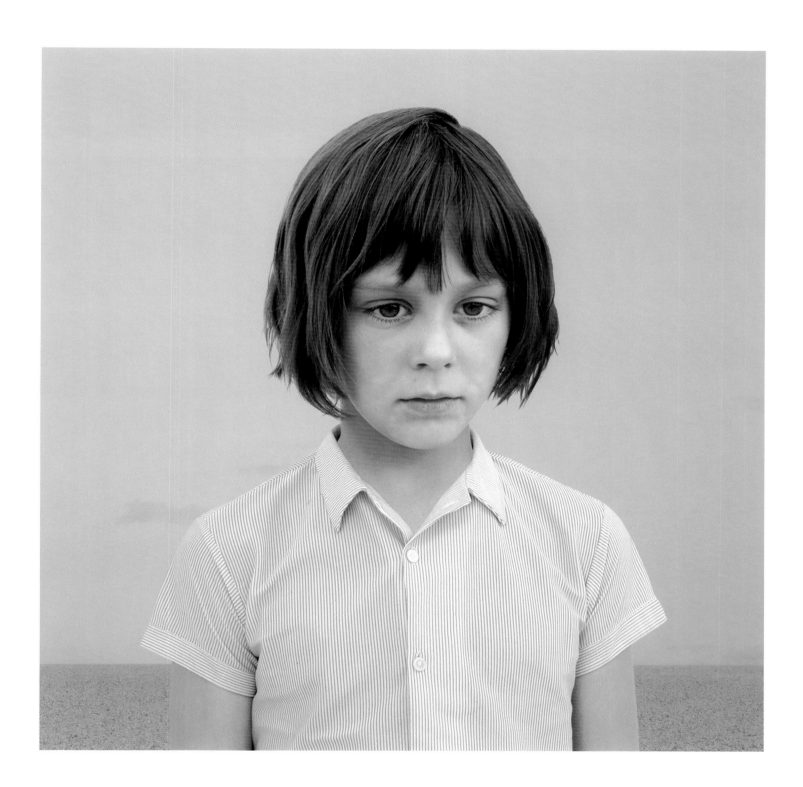

Maria 1, 2001

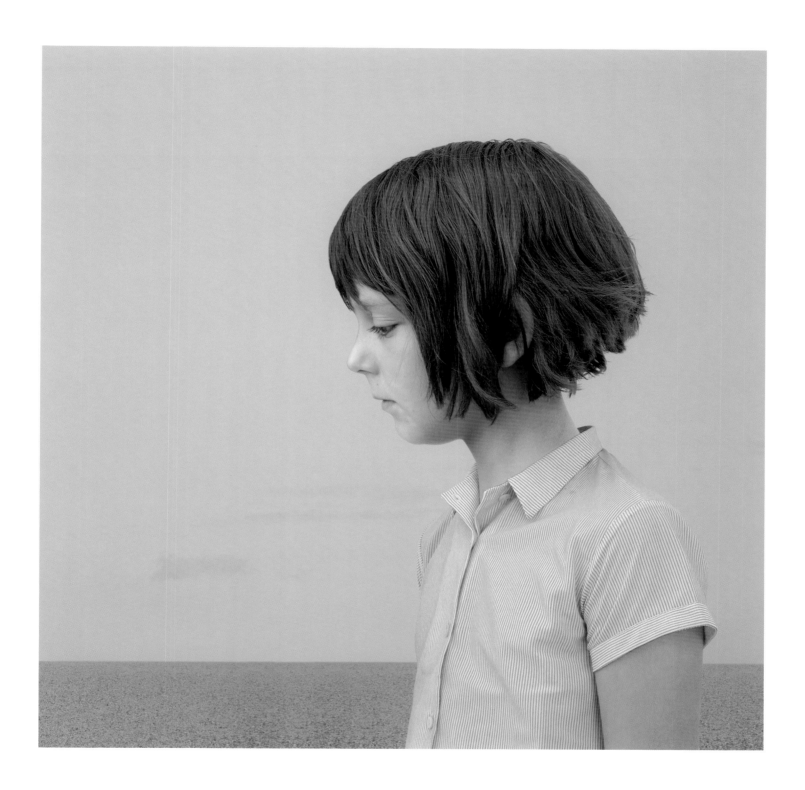

Maria 2, 2001

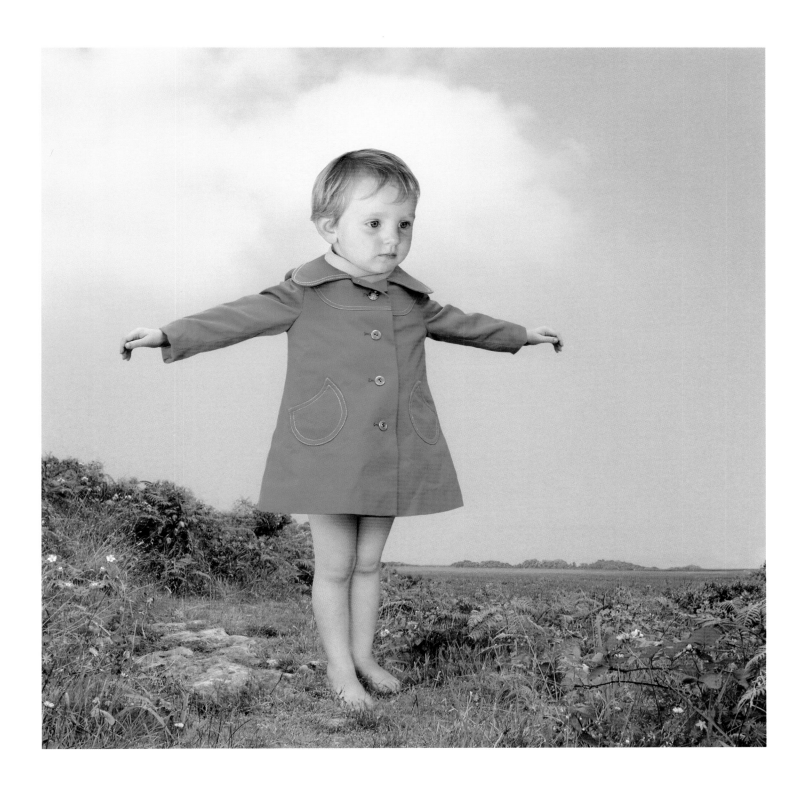

Spring, 2001

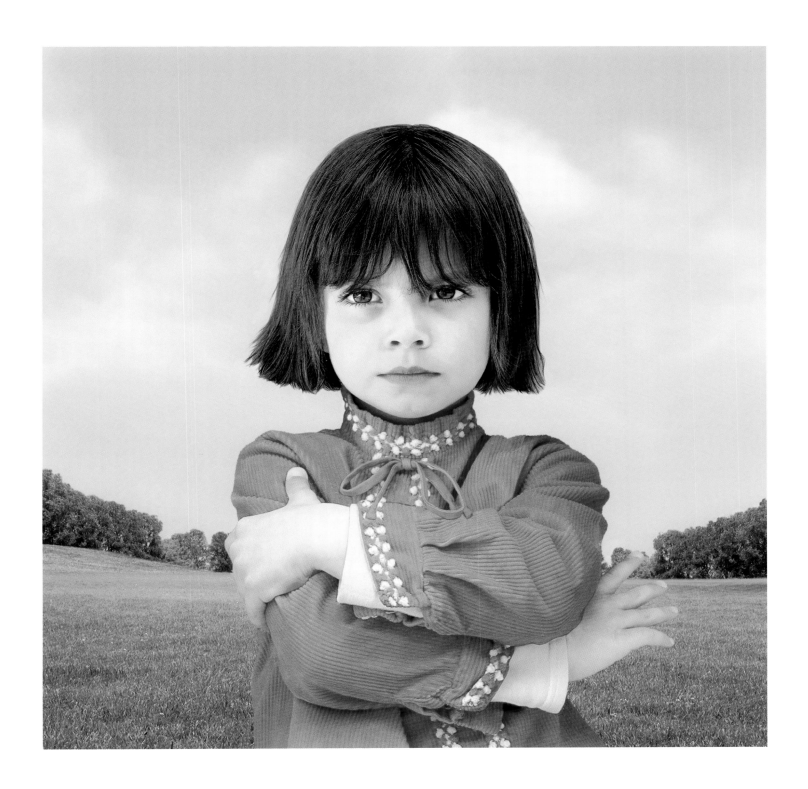

Girl with Crossed Arms, 2001

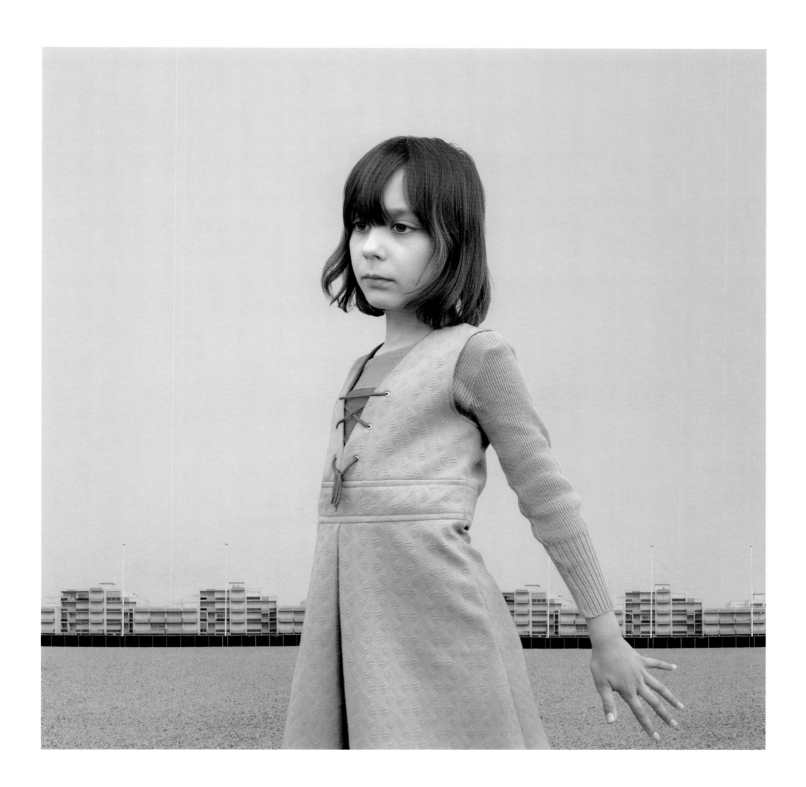

The Blue Dress, 2001

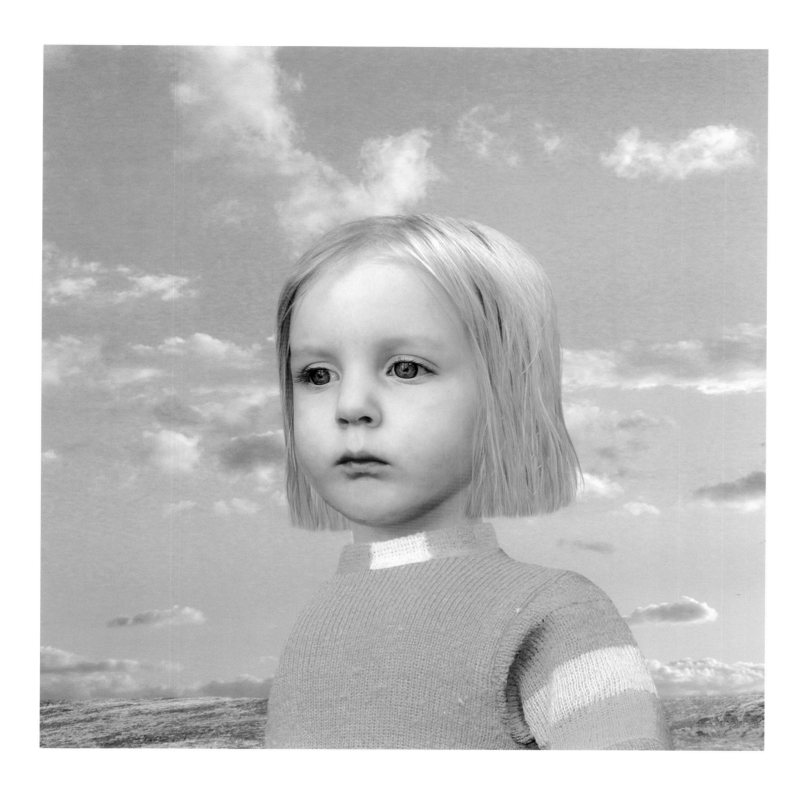

Dorothea, 2001

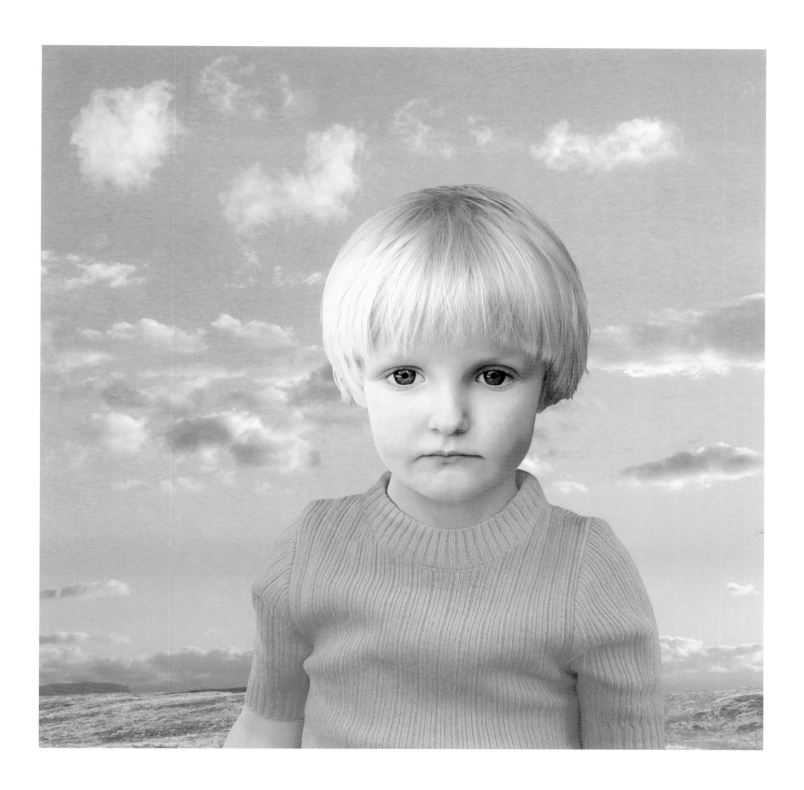

Isabella, 2001

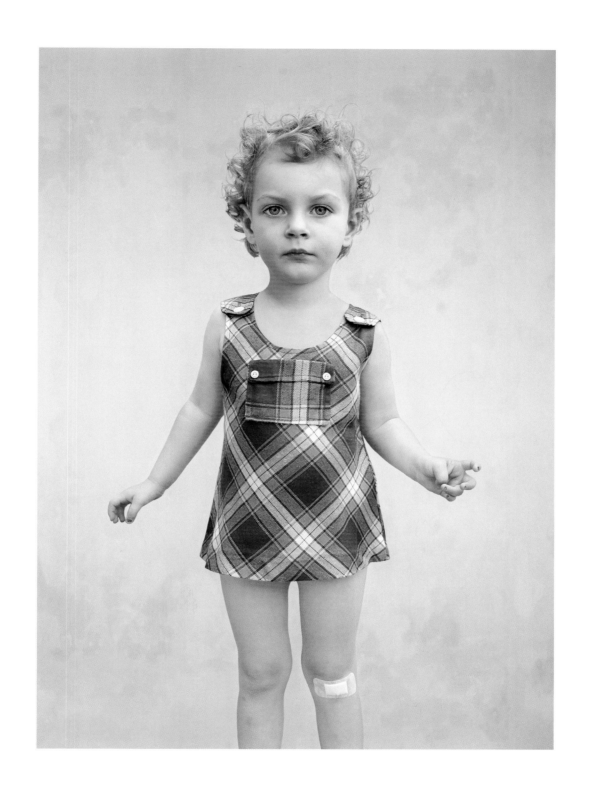

Study of a Girl 1, 2001

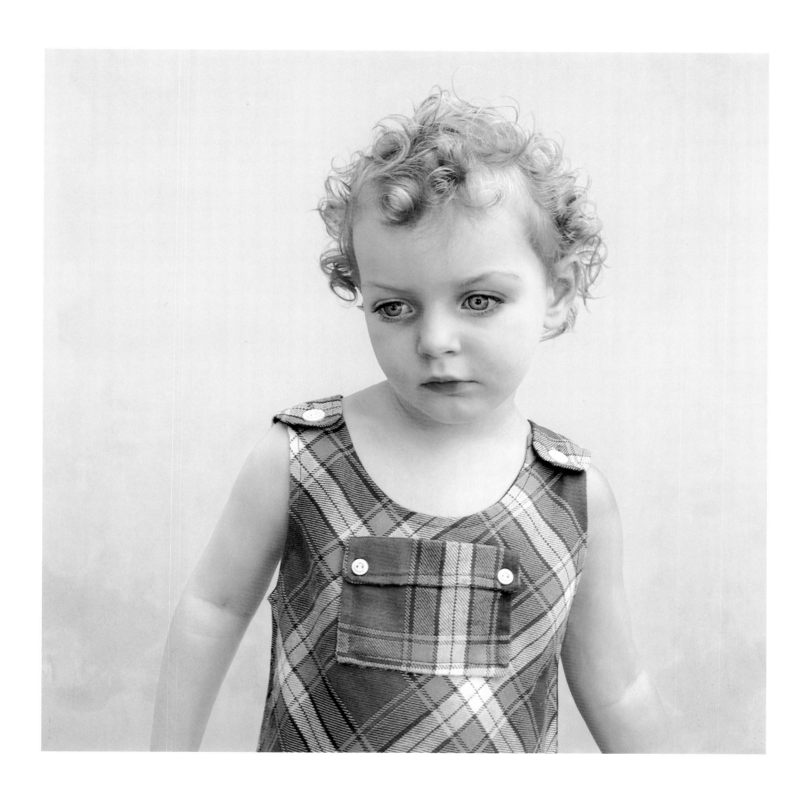

Study of a Girl 2, 2002

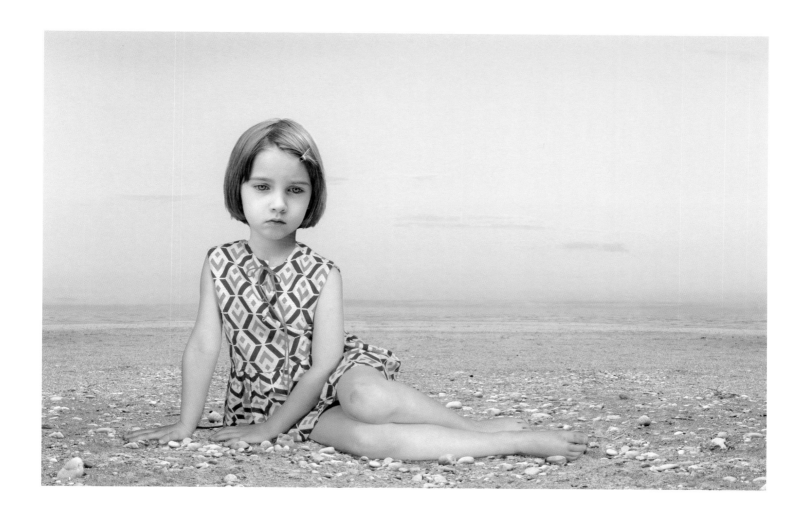

Paulin, 2002

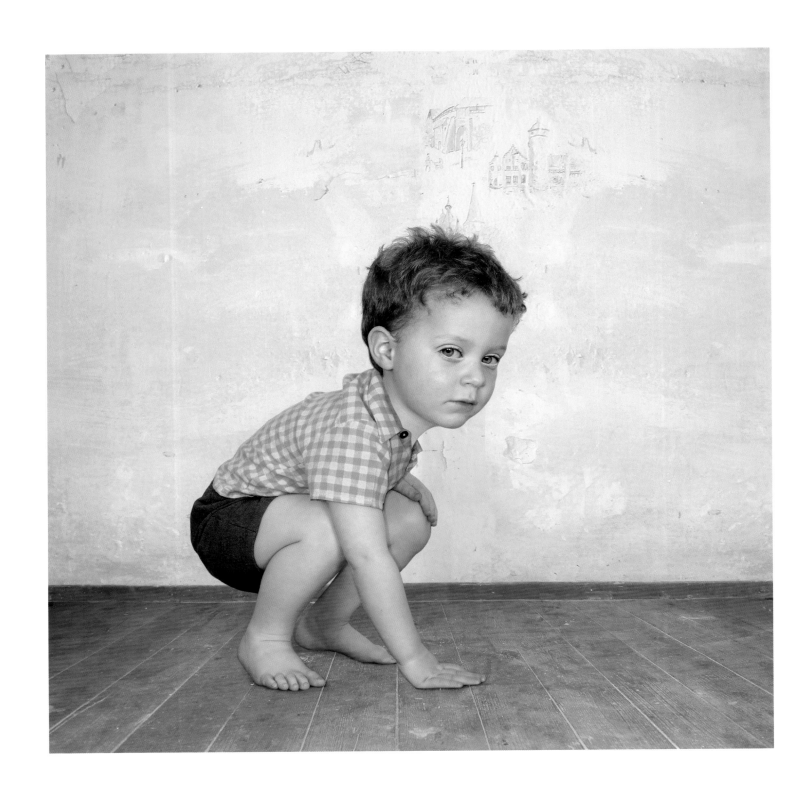

Study of a Boy 1, 2002

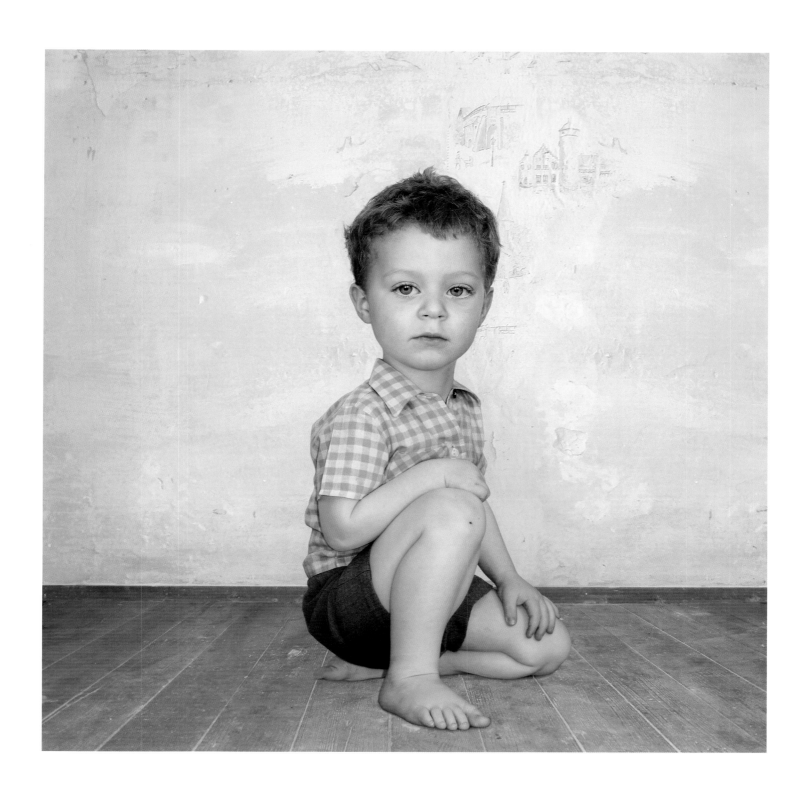

Study of a Boy 2, 2002

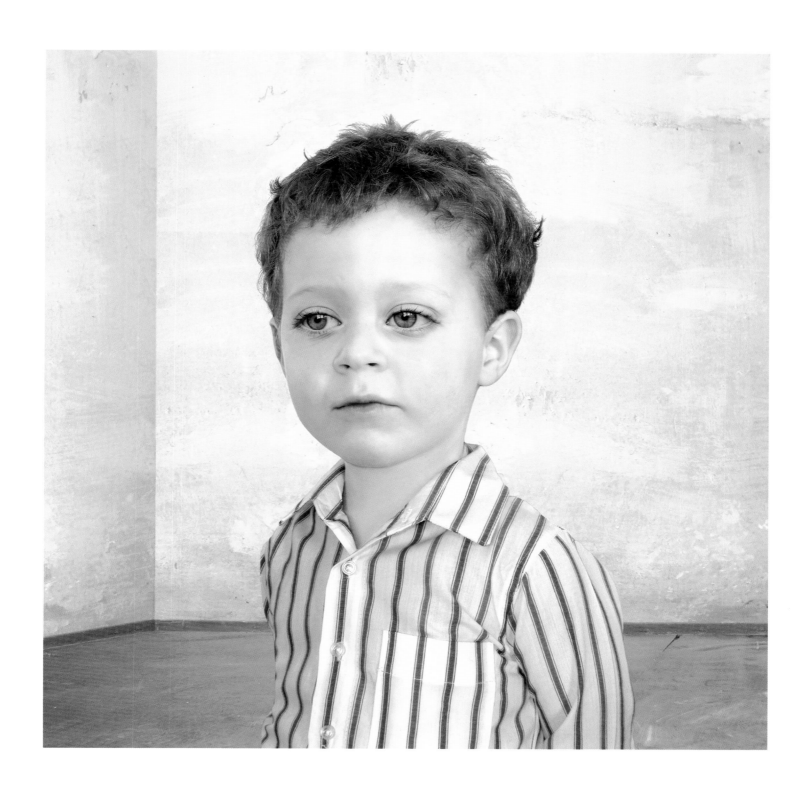

Study of a Boy 3, 2002

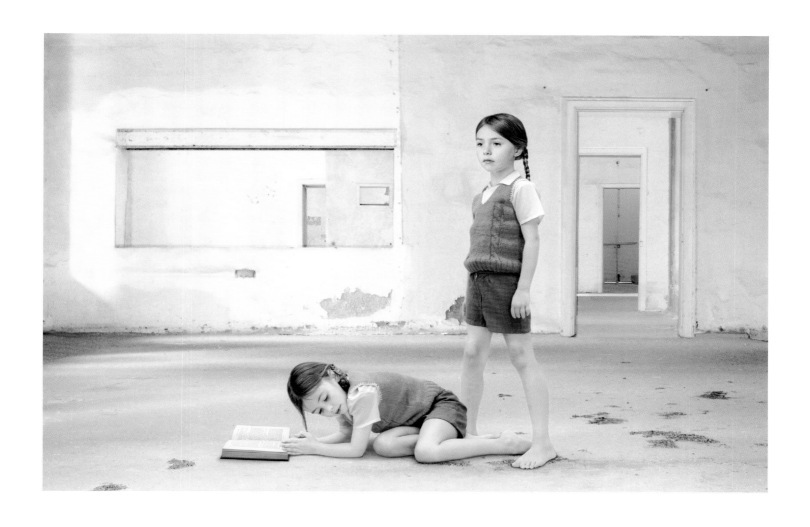

The Book, 2003

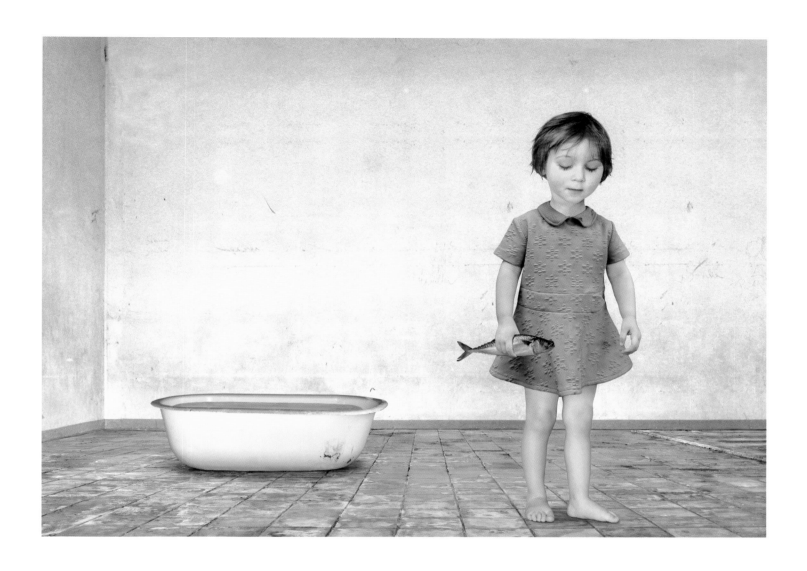

The Fish, 2003

The Hunter, 2003

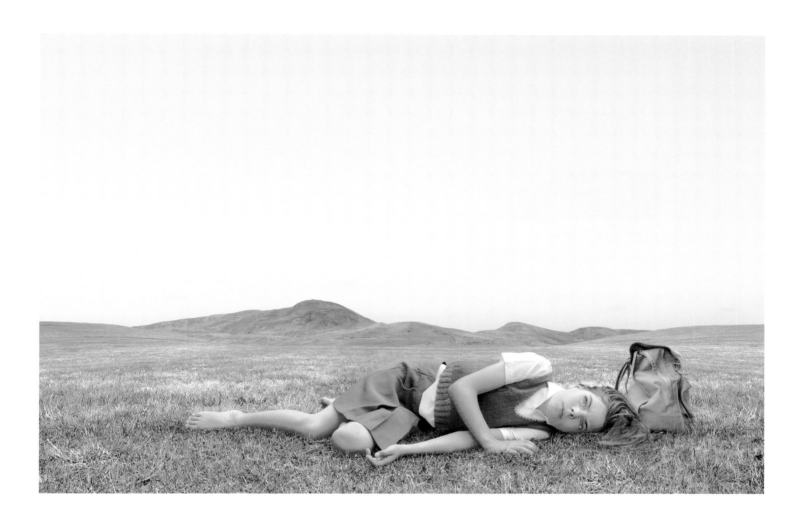

The Wanderer, 2003

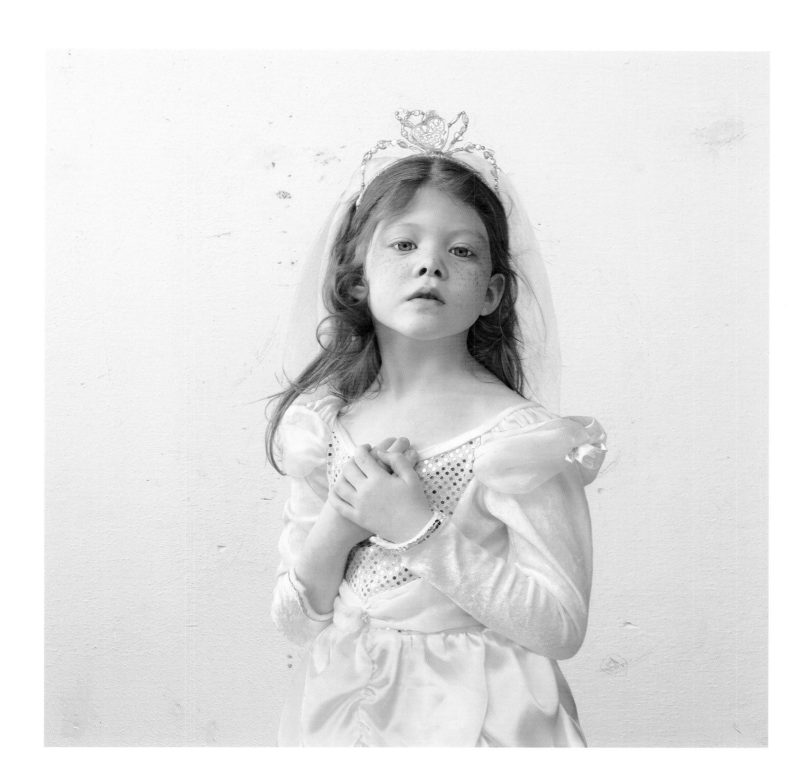

The Bride, 2003

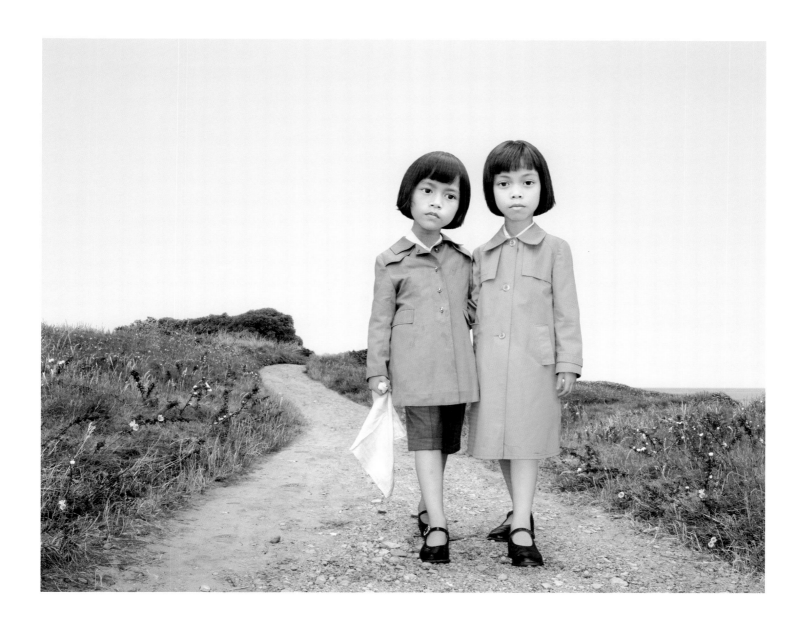

The Walk, 2004

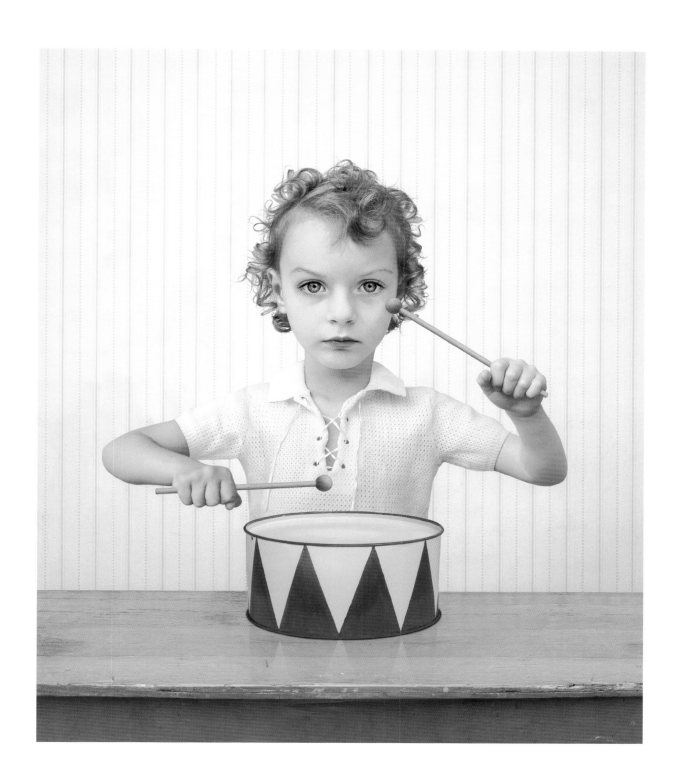

The Drummer, 2004

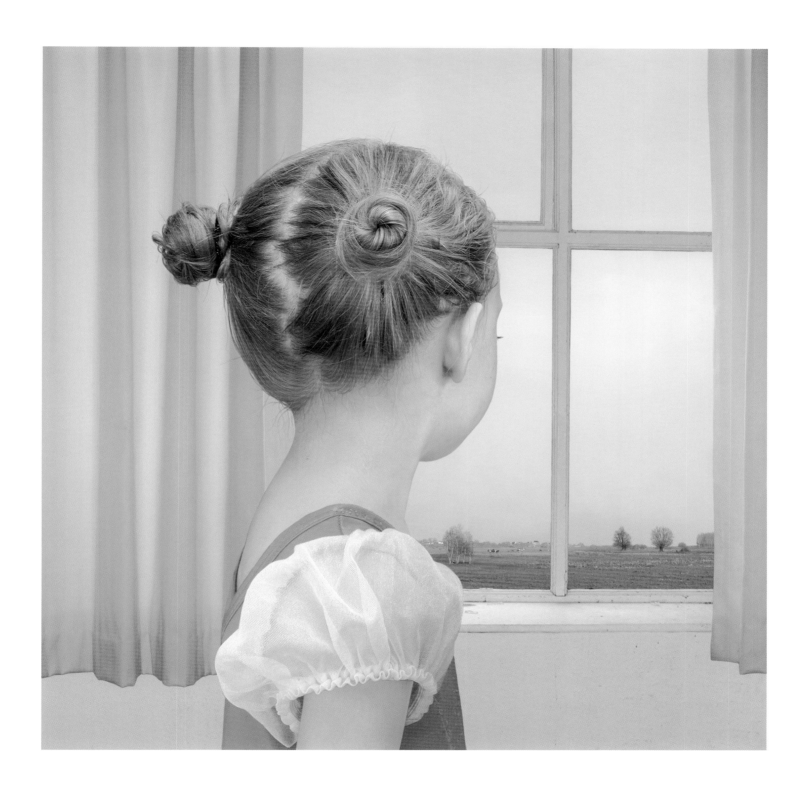

At the Window, 2004

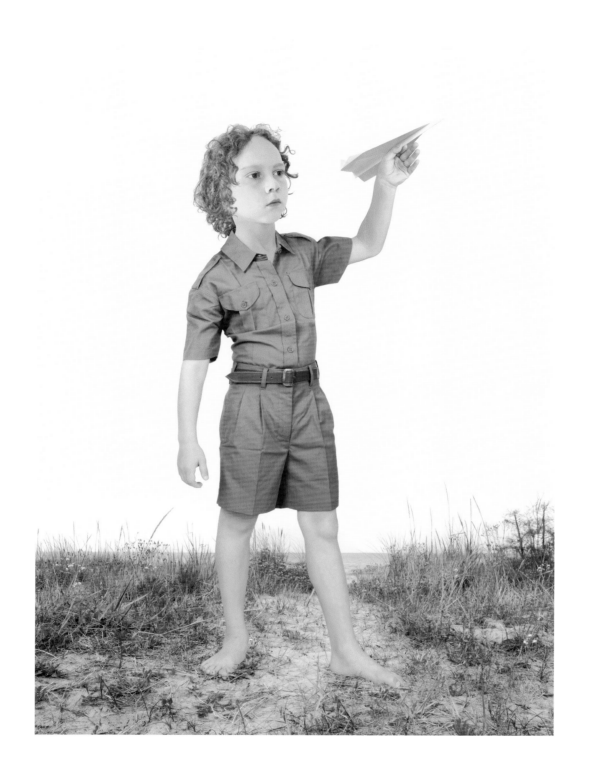

The Paper Airplane, 2004

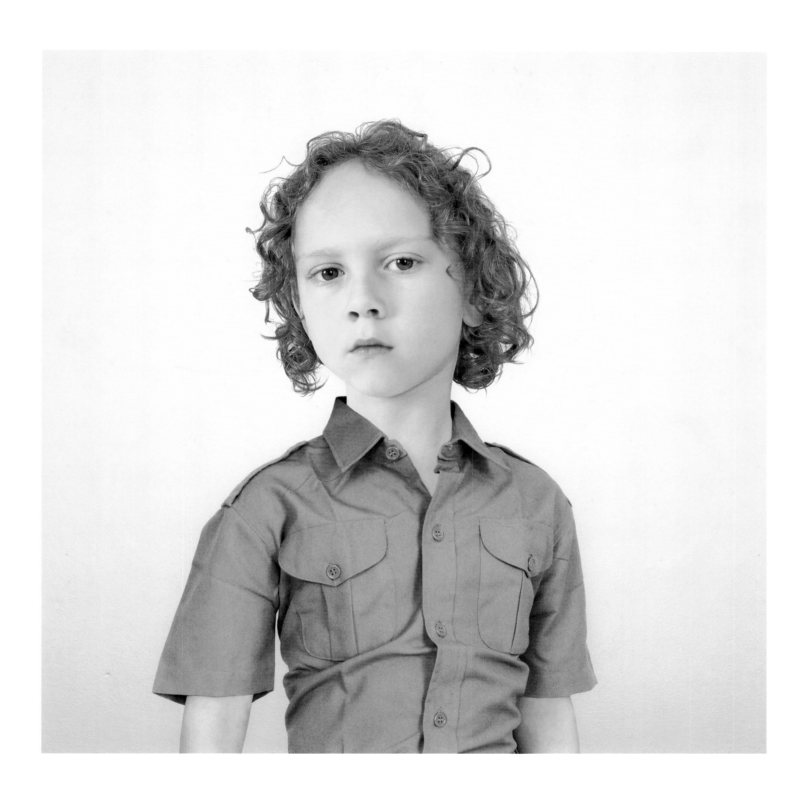

Milo 2, 2004

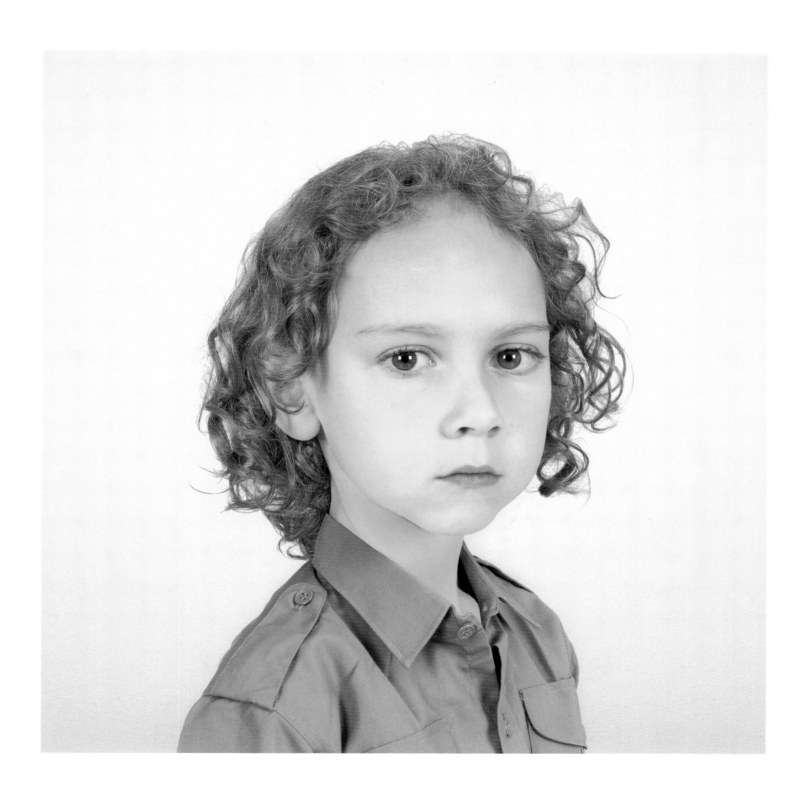

Milo 1, 2004

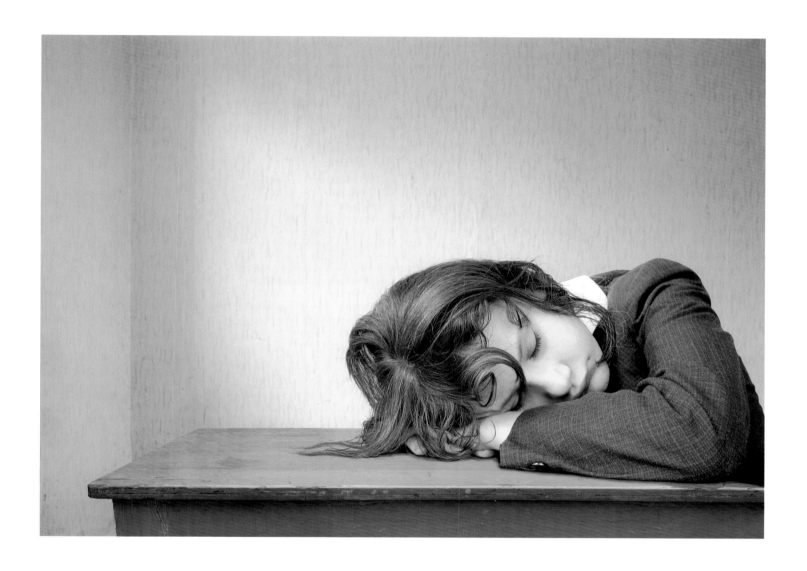

Yanan, 2004

ACKNOWLEDGMENTS

Loretta Lux

Yossi Milo, Martin Kern, Annemarie Kirsten, Klaus von Gaffron, Doris Schechter, Anita Krapf, Kerstin Rajakowitsch, Elizabeth and James Schofield, Carl and Lisa Kirchner, Fred and Frida Latzke, Josef Meckl, Peter Sellmeier, Gerd Winner, Evan Smoak, Ulla Gröne, Adriaan van der Have, Dr. Gernot Schulze, and Günther and Regina Jost.

Special thanks to all my wonderful models.

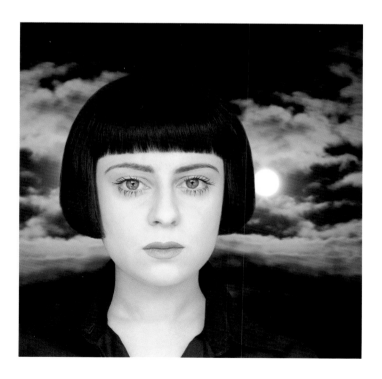

Self-Portrait, 2000

CHRONOLOGY

1969

Born in Dresden, East Germany.

1989

Leaves Dresden for Munich, a few months before the fall of the Berlin Wall.

1990–96

Studies painting at Akademie der Bildenden Künste, Munich, with Professor Gerd Winner.

1999

Begins making photographs.

2004

Moves to Ireland.

2005

Moves to Monaco. Receives Infinity Award for Art, International Center of Photography, New York.

SOLO EXHIBITIONS

2004

Loretta Lux, Yossi Milo Gallery, New York

Loretta Lux, Torch Gallery, Amsterdam

2003

Loretta Lux, Stadtmuseum, Münster, Germany

SELECTED GROUP EXHIBITIONS

2005

Arbeit an der Wirklichkeit: German Contemporary Photography, National Museum of Modern Art, Tokyo; National Museum of Modern Art, Kyoto; Marugame Genichiro-Inokuma Museum of Contemporary Art, Japan

Focus On: New Photography, Norton Museum of Art, West Palm Beach, Florida

In Focus: Contemporary Photography from the Allen G. Thomas Jr. Collection, North Carolina Museum of Art, Raleigh

Inventing Childhood, Aukland Art Gallery, New Zealand

Through the Looking Glass, Lewis Glucksman Gallery, University College Cork, Ireland

2004

About Face: Photographic Portraits from the Collection, Art Institute of Chicago

About Face, Hayward Gallery, London

Changelings, Australian Centre for Photography, Sydney

Making Faces, Musée de l'Elysée, Lausanne, Switzerland

The Picture of Innocence, Frist Center for the Visual Arts, Nashville, Tennessee

La Collection Ordóñez-Falcón, Le Botanique, Brussels

2003

By the Sea, Yossi Milo Gallery, New York

Niños, Centro de Arte de Salamanca, Spain

PUBLIC COLLECTIONS

Akron Art Museum, Ohio

Art Institute of Chicago

Brooklyn Museum of Art

Cleveland Museum of Art

Fotomuseum den Haag, The Hague

Fotomuseum München, Munich

Fotomuseum Winterthur, Switzerland

Israel Museum, Jerusalem

Knoxville Museum of Art, Tennessee

Los Angeles County Museum of Art

Maison Européenne de la Photographie, Paris

Musée de l'Elysée, Lausanne, Switzerland

Museum of Contemporary Art, Los Angeles

Museum of Fine Arts, Houston

Museum of Photographic Arts, San Diego

New Orleans Museum of Art

Norton Museum of Art, West Palm Beach, Florida

Rhode Island School of Design Museum, Providence

San Francisco Museum of Modern Art

Solomon R. Guggenheim Museum, New York

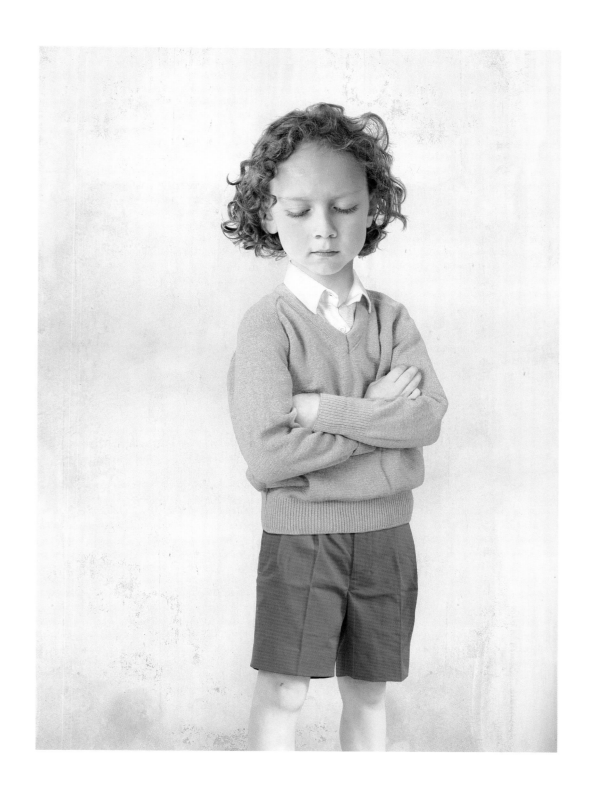

Boy in Yellow Pullover, 2004

Front cover: *Isabella*, 2001
Back cover: *At the Window*, 2004
Frontispiece: *Marianne*, 2004

All the photographs are Ilfochrome prints.

———————————

Editor: Nancy Grubb
Designer: Francesca Richer
Production: Lisa Farmer

The staff for this book at Aperture Foundation includes:
Ellen S. Harris, *Executive Director*; Roy Eddey, *Director of Finance and Administration*;
Lesley A. Martin, *Executive Editor, Books*; Andrea Smith, *Director of Publicity*;
Linda Stormes, *Director of Sales & Marketing*; Michael Itkoff and Ursula Damm, *Work Scholars*

First edition
Printed and bound by Sing Cheong Printing Co., Ltd., Hong Kong
10 9 8 7 6 5 4

Library of Congress Control Number: 2004113573
ISBN-13: 978-1-931788-54-0 ISBN-10: 1-931788-54-5

Aperture Foundation books are available in North America through:
D.A.P./Distributed Art Publishers
155 Sixth Avenue, 2nd Floor, New York, N.Y. 10013
Phone: (212) 627-1999 Fax: (212) 627-9484

Aperture Foundation books are distributed outside North America by:
Thames & Hudson
181A High Holborn, London WC1V 7QX, United Kingdom
Phone: + 44 20 7845 5000 Fax: + 44 20 7845 5055
Email: sales@thameshudson.co.uk

aperturefoundation
547 West 27th Street
New York, N.Y. 10001
www.aperture.org

The purpose of Aperture Foundation, a non-profit organization, is to advance photography in all its forms
and to foster the exchange of ideas among audiences worldwide.